T0064861

Identity Pitches

Stine Janvin
Cory Arcangel

PatteГиs'

Patterns

Setesdal

The *Setesdalskofte* comes from the valley district of Setesdal in southern Norway and features the characteristic *luse* ("lice") pattern that has given *lusekofte*, or "lice jacket," its name. A classic pattern, it is perhaps the most commercialized of the Norwegian knitting designs and has been copied and modified in countless ways. It was originally made from sheep's wool, with an undyed black or brown base with white and beige detailing. The upper body, neckline, and sleeves are richly decorated with colorful embroidery and tin or silver buttons.

Fana

Fanakofte features horizontal stripes and was first produced by the Norwegian yarn company Sandnes Uldvarefabrik (Sandes Garn today). Popular in the late 1870s, and to this day one of the best-selling activewear *koftes*, the design was inspired by everyday clothing for men in nineteenth-century Fana, a borough of Bergen, though similar men's shirts are found all over Norway. Its characteristic stripes are punctuated by lice stitching, while its sleeves and bottom hem feature a checkerboard pattern; there are eight-pointed stars on the upper sleeves and shoulders.

Selbu

The origin of the Selbu pattern is unclear, as the octagram design it prominently features seems to have been in widespread use in many countries and in other parts of Norway years before it came to the region of Selbu. However, according to one account, it was first created by a young girl from Selbu in 1857; she was then encouraged to hand her patterns over to the local handicrafts association. Thanks to extensive promotion in the following years, her design of an eight-petaled rose, or *Selburose,* is now internationally known as the "Norwegian star."

Setesdal

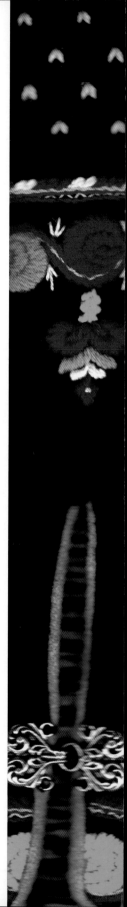

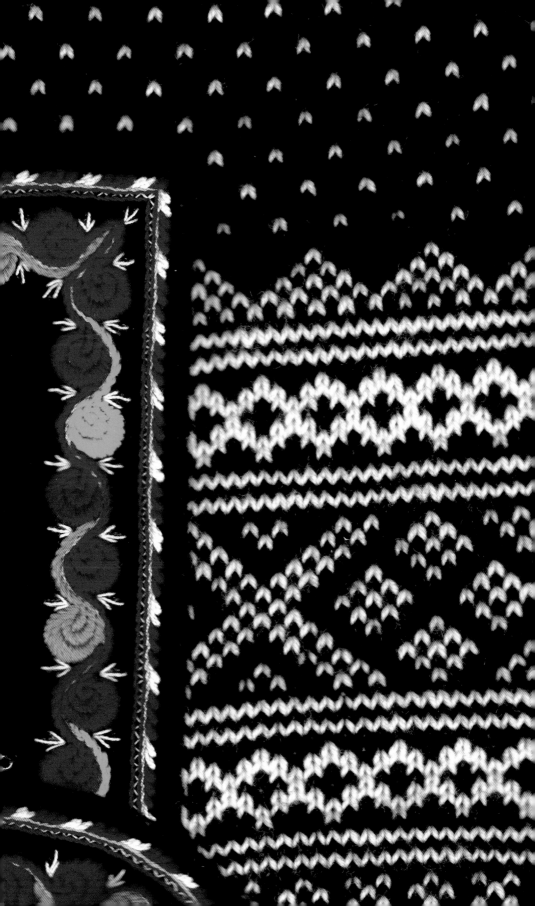

Fana

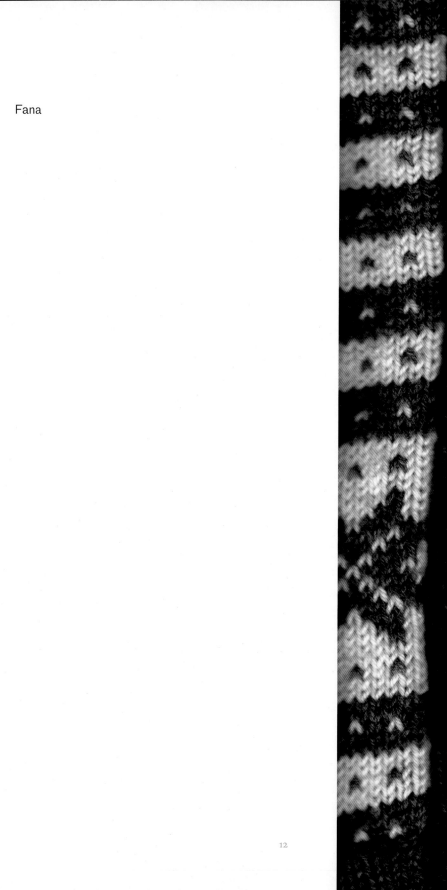

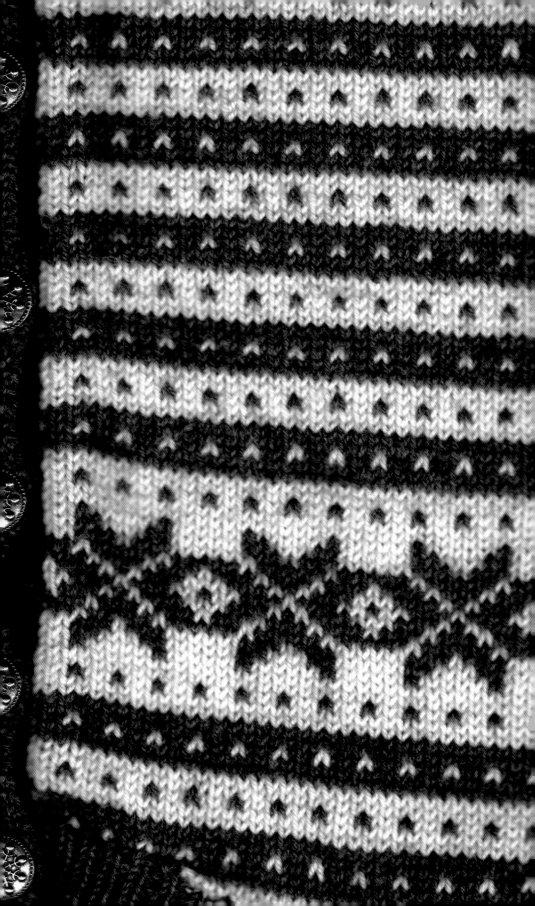

Selbu

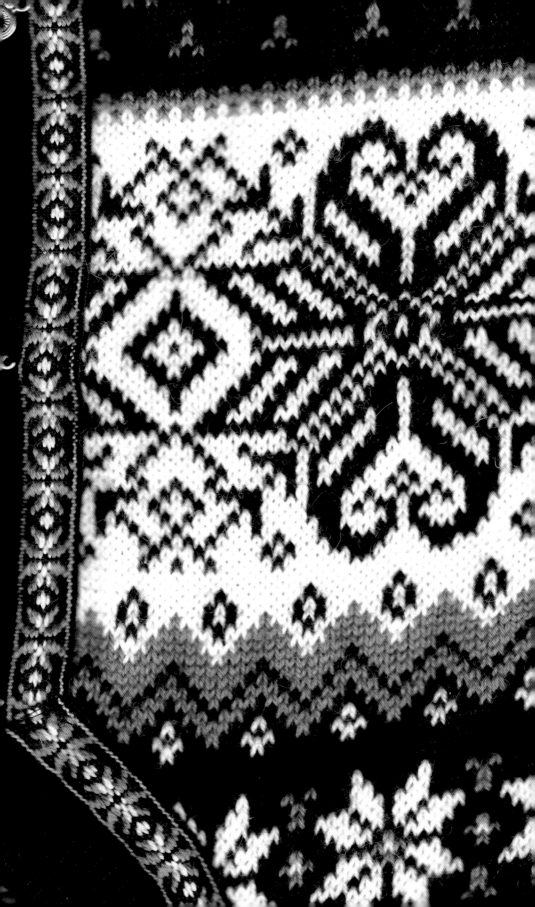

By Cory Arcangel & Stine Janvin

It was a bright sunny day in 2019—the kind that can seem to last forever in a Norwegian summer—when we first met on a playdate with our kids in Stavanger. From where we were standing, we could see the sparkling blue Lysefjord, and the snow-capped mountains behind it.

Stine grew up in Stavanger and had just moved back from Berlin with her partner, Morten, and one-year-old, Isof, after being away for ten years. They were longing for nature and had initially considered moving to a farmhouse somewhere remote, but they ended up in a wooden house in Stavanger, which seemed close enough. For Stine, the journey home had awakened an interest in identity—what was Norway, besides brown cheese, petroleum, and the "world's best country for quality of life"? She began researching traditional folk songs, crafts, and costume, and started to integrate elements of these into her work.

Over the course of her research, Stine became aware of the relationship between Norwegian folk music and the harmonic series. The tonality of folk music found in archival recordings is microtonal, floating between minor and major. Deploying just intonation to analyze and transcribe these melodies allows one to pinpoint practically any pitch, as opposed to the limitations of the fixed twelve tones of Western classical music. For instance, if you play all the keys on the piano from the lowest to the highest C, the distance between each tone is the same. By contrast, in the harmonic series (which is closely interconnected with just intonation), the distance between each tone continues to become smaller and smaller in microtonal intervals.

↳

Cory had come to Stavanger with his wife, Hanne, a few years before to welcome their daughter, Embla. Since then, he'd found that many of the life skills learned after fifteen years in New York were not much help for a life in southwestern Norway—there, even the sun traveled in a different arc in the sky! Nonetheless, he was slowly picking up the basics of Norwegian culture. One of his recent discoveries was that wool is a kind of magic substance, and that Norwegian children grow up wrapped in layers of wool, like little lambs. Embla has a wool undershirt that she calls her "cozy," and she wears it under everything, even in summer. It's protective for her, both practically and poetically.

Still disoriented from his crash landing after leaving New York, Cory had grasped onto his virtual life, one of the few things that had remained constant in the move. In particular, he had been thinking about the everyday lives of images as they are thrown from server to server, and was playing around with a simple "deep-frying" script that would iteratively compress and mangle an image through various processes, in the hopes that he could incorporate the results into his work at some point.

We spoke about these topics. Summer days in Stavanger are long and bright, but not necessarily warm, and as the sun was about to disappear behind a rooftop and leave our ocean-view playground in freezing shade, we took refuge in the Arcangel Surfware Flagship shop, Cory's (then) HQ for his publishing and merchandise company, Arcangel Surfware. There—amid Arcangel Surfware hoodies and fidget spinners—our conversation about the vernacular lives of images eventually turned to vernacular Norwegian fashion, or lusekoftes, which Cory had just realized were not merely tourist souvenirs, but pieces of clothing that are casually and unironically worn by Norwegians every day. Thus the spark that led to this book emerged.

So this book's origin story is very much rooted in our physical and temporal convergence, and the meeting of our practices here in Stavanger. Inspired by the tuning principles of traditional Norwegian instruments—the mouth harp, lur, and willow flute—we have given a selection of Norwegian knitting patterns the function of graphic scales and scores assigned to the harmonic and subharmonic series. The patterns all have a centerline, which represents the reference frequency—also called the fundamental—that all the other tones relate to. These knitting patterns and scores are themselves mirrored and "detuned" by Cory's deep-frying script, emerging as both alternative scores and possible knitting patterns.

Identity Pitches

Identity Pitches

For any number of players and any instrument.

The knitting patterns Setesdal, Fana, and Selbu are mapped to the harmonic and subharmonic series shown by the numbers to the left.

Each number represents a harmonic or subharmonic partial relating to the fundamental.

Each player is responsible for one or several tones. A score can also be performed by a solo player recording each part individually.

Setesdal consists of three sections—A, B, and C—and these should be played in alphabetical order.

All scores may be played separately as individual pieces or together as three movements in any order.

The centerline of the pattern is your fundamental, and all other tones are marked on the lines underneath and above.

✕ = tone
☐ = pause/silence

The pattern should be read from left to right.

Each part is represented by a horizontal line (left to right).

All tones in each vertical line (up or down from the centerline) should be played approximately simultaneously.

Lengths of tones and pauses are to be determined by the players, who may use individual timing, but lengths should be consistent throughout each pattern.

All tones may be played in any octave, and players may vary between octaves throughout each pattern.

The piece ends when all players have played all of their assigned tones.

The reference pitch in the centerline and the tempo are optional and to be decided by the performer(s) according to instrumentation and range. For instance, ref.pitch: A440, bpm: 60.

The reference pitch and tempo may be different for each pattern.

A

Setesdal

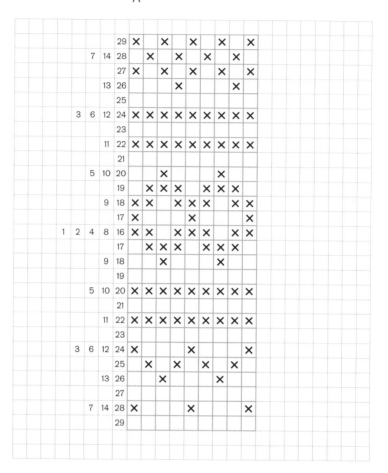

B

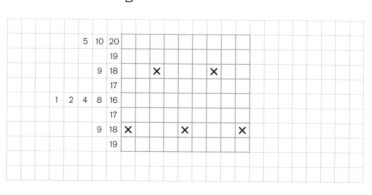

C

The chart is a 25-column grid with row/stitch count labels down the left side (reading top to bottom):

		21	42	
			41	
1	5 10	20	40	
			39	
		19	38	
			37	
	9	18	36	
			35	
		17	34	
			33	
1 2 4	8	16	32	
			31	
		15	30	
			29	
	7	14	28	
			27	
		13	26	
			25	
	3 6	12	24	
			23	
		11	22	
			21	
	5	10	20	
			19	
	9	18		
			17	
1 2 4	8	16		
			17	
	9	18		
			19	
	5	10	20	
			21	
		11	22	
			23	
	3 6	12	24	
			25	
		13	26	
			27	
	7	14	28	
			29	
		15	30	
			31	
1 2 4	8	16	32	
			33	
		17	34	
			35	
	9	18	36	
			37	
		19	38	
			39	
	5 10	20	40	
			41	
		21	42	

Setesdal

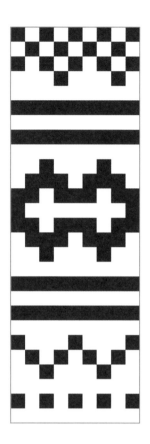

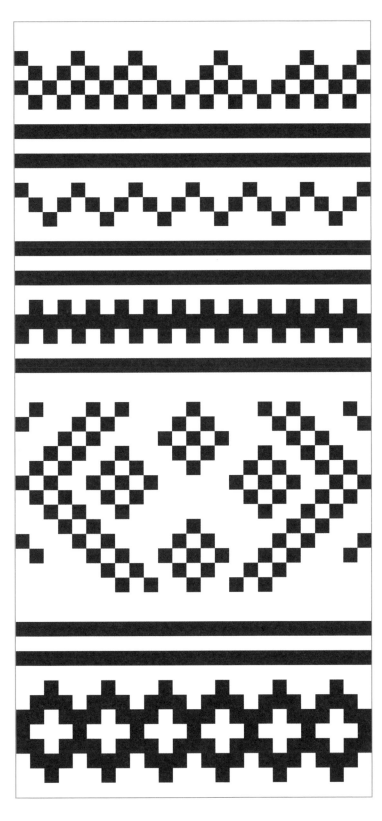

Fana

Knitting/cross-stitch pattern chart (13 stitch columns wide). Guide columns on the left show row-number divisors; the right-hand grid shows the stitch symbols (✗).

					Row	1	2	3	4	5	6	7	8	9	10	11	12	13
			9	18	36	✗	✗	✗	✗	✗	✗	✗	✗	✗	✗	✗	✗	✗
					35	✗	✗	✗	✗	✗	✗	✗	✗	✗	✗	✗	✗	✗
				17	34		✗	✗			✗	✗			✗	✗		
					33	✗	✗	✗	✗	✗	✗	✗	✗	✗	✗	✗	✗	✗
1	2	4	8	16	32	✗	✗	✗			✗	✗	✗	✗			✗	✗
					31	✗	✗	✗				✗	✗	✗			✗	✗
				15	30	✗	✗	✗					✗				✗	✗
					29			✗						✗				
			7	14	28	✗				✗				✗				✗
					27	✗	✗				✗		✗				✗	✗
				13	26	✗	✗	✗				✗				✗	✗	✗
					25	✗	✗				✗		✗				✗	✗
		3	6	12	24	✗				✗				✗				✗
					23			✗						✗				
				11	22	✗	✗	✗				✗				✗	✗	✗
					21	✗	✗	✗			✗	✗	✗			✗	✗	✗
			5	10	20	✗	✗	✗		✗	✗	✗	✗	✗		✗	✗	✗
					19	✗	✗	✗	✗	✗	✗	✗	✗	✗	✗	✗	✗	✗
			9	18		✗	✗			✗	✗			✗	✗			✗
				17		✗	✗	✗	✗	✗	✗	✗	✗	✗	✗	✗	✗	✗
	1	2	4	8	16	✗	✗	✗	✗	✗	✗	✗	✗	✗	✗	✗	✗	✗
					17													
			9	18														
					19	✗			✗			✗			✗			✗
			5	10	20													
					21													
				11	22	✗	✗	✗	✗	✗	✗	✗	✗	✗	✗	✗	✗	✗
					23	✗	✗	✗	✗	✗	✗	✗	✗	✗	✗	✗	✗	✗
		3	6	12	24		✗	✗		✗	✗		✗	✗		✗	✗	
					25	✗	✗	✗	✗	✗	✗	✗	✗	✗	✗	✗	✗	✗
				13	26	✗	✗	✗	✗	✗	✗	✗	✗	✗	✗	✗	✗	✗
					27													
			7	14	28													
					29	✗			✗			✗			✗			✗
				15	30													
					31													
1	2	4	8	16	32			✗	✗	✗				✗	✗	✗		
					33			✗	✗	✗				✗	✗	✗		
				17	34			✗	✗	✗				✗	✗	✗		
					35	✗	✗				✗	✗	✗				✗	✗
			9	18	36	✗	✗				✗	✗	✗				✗	✗
					37	✗	✗				✗	✗	✗				✗	✗

Fana

Selbu

					35	X		X
				17	34		X	X
					33	X	X	X
1	2	4	8	16	32			
					31		X	X
				15	30			
					29			X
			7	14	28	X		
					27			
				13	26			X
					25		X	X
		3	6	12	24	X	X	
					23	X	X	
				11	22	X	X	
					21	X	X	
			5	10	20		X	X
					19			X
				9	18			
					17	X		
	1	2	4	8	16	X	X	
					17	X		
				9	18			
					19			X
			5	10	20		X	X
					21	X	X	
				11	22	X	X	
					23	X	X	
		3	6	12	24	X	X	
					25		X	X
				13	26			X
					27			
			7	14	28	X		
					29			X
				15	30			
					31		X	X
1	2	4		16	32			
					33	X	X	X
				17	34		X	X
					35	X		X

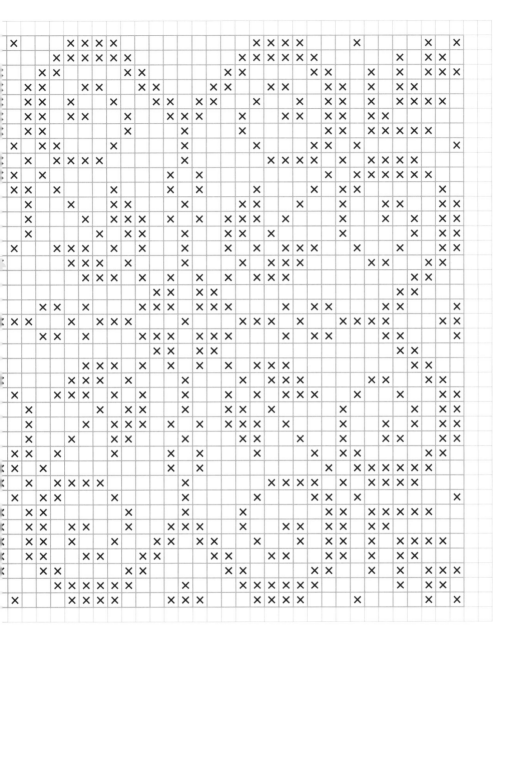

Selbu

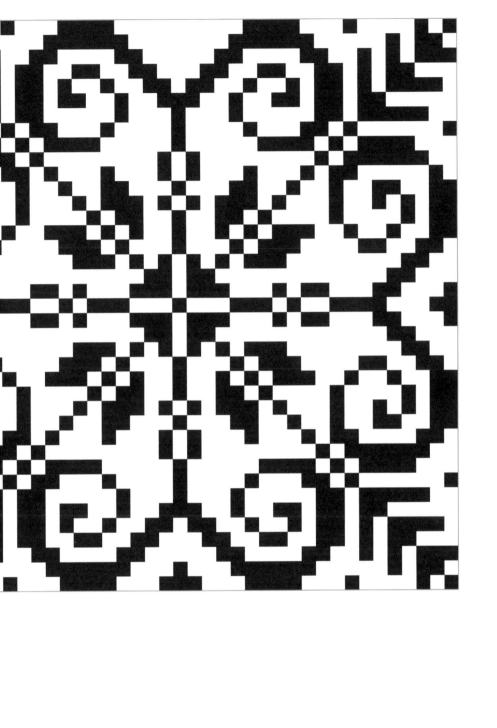

Deepk°FtƎ

Deepkofte

```
                _.--.
              ;.-'i.`._.--,
             {(;{} y`-.`,_-`--.
             <`~;`-( _.'`.~`.' \
              \  `i.'  `  Y  },-,)
            .j~. |        ;  / _j\
            <_   `!       ;_.'( /
             >-,   `---.,'  .'-j
            /   `.   ,<_  ( `. \
             `=-j\ `_
       *           * *
        *        *    *
     <*     *     *
        *    *     *
        *   *     *
        * *    *
       * *   *
      ** *
       * *
        *
        *
```

unknown

DEEP FRYER
Contributors: Cory Arcangel, Henry Van Dusen

Requires [imagemagick](https://imagemagick.org/script/download.php)

Usage:

 ./deepfry.sh -n 10 -o output -s 1 -f selbu.jpg

optional args:
`-f` image_file (default: selbu.jpg)
`-n` iterations (default: 100)
`-s` save every (default: all)
`-o` output_directory (default: output)

Code

```bash
#!/usr/bin/env bash

file=selbu.jpg
destination=output
iterations=10
save=1
while [ ! $# -eq 0 ]
do
  case "$1" in
    -f) file=$2
            ;;
    -n) iterations=$2
            ;;
    -o) destination=$2
            ;;
    -s) save=$2
            ;;
    *) file=$1
  esac
  shift
done
size=$(identify -format "%[fx:w]x%[fx:h]" $file)
echo 'deep frying file: '$file 'destination: '$destination
    'iterations: '$iterations 'size: '$size 'save: '$save
extension="${file##*.}"                    # get the extension
filename="${file%.*}"                       # get the filename
cp "$file" "wrkn.jpg"              # rename file by moving it

for (( i = 1; i <= $iterations; i++ )); do

# Where are we
echo -n $i'-'

# Random option
operation=$((0 + $RANDOM % 4))

# Modulate x factor
if [[ $operation = "0" ]]; then
    factor=$((100 + $RANDOM % 200))
    command='convert wrkn.jpg -modulate 100,'$factor' wrkn.jpg'
    echo $command
        $command

# Compress x quality
elif [[ $operation = "1" ]];
then
    factor_compress=$((1 + $RANDOM % 100))
```

```bash
47      factor_size=$((25 + $RANDOM % 75))
48      command='convert wrkn.jpg -scale '$factor_size'  wrkn.jpg'
49      echo $command
50          $command
51      command='convert wrkn.jpg -compress JPEG2000 -quality
                    '$factor_compress' wrkn.jpg'
52      echo $command
53          $command
54      command='convert wrkn.jpg -scale '$size\!' wrkn.jpg'
55      echo $command
56          $command
57
58  # Contrast x 0xfactor
59  elif [[ $operation = "2" ]];
60  then
61      factor=$((10 + $RANDOM % 40))
62      command='convert wrkn.jpg -brightness-contrast 0x'
                    $factor' wrkn.jpg'
63      echo $command
64          $command
65
66  # Resize
67  elif [[ $operation = "3" ]];
68  then
69          factor=$((1 + $RANDOM % 20 + 80))
70          command='convert wrkn.jpg -scale '$factor'
                    -scale '$size\!' wrkn.jpg'
71          echo $command
72              $command
73
74  # Sharpen x 0xfactor
75  else
76              factor=$((3 + $RANDOM % 10))
77          command='wrkn.jpg -sharpen 0x'$factor' wrkn.jpg'
78          echo $command
79              $command
80  fi
81
82  #dump every so often.
83  if [  $(($i % $save)) -eq 0 ]
84  then
85          cp "wrkn.jpg" "$destination/$filename-step-$i.jpg"
86  fi
87
88  done
89
90  #delete wrkn file
91  rm wrkn.jpg
```

A

Setesdal

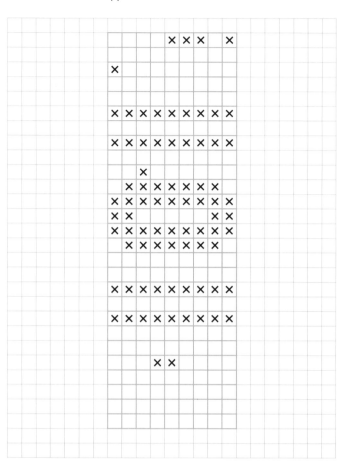

B

C

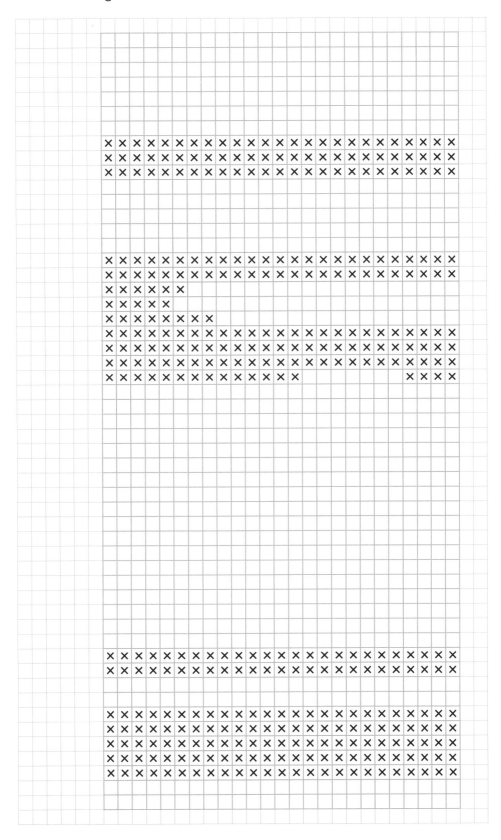

Setesdal

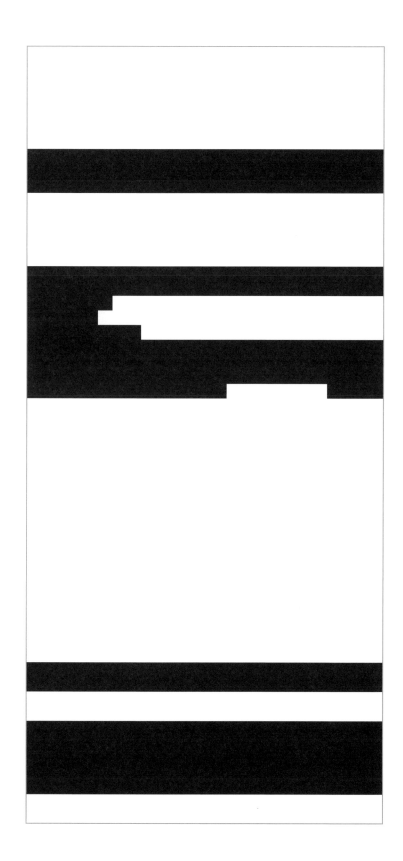

Fana

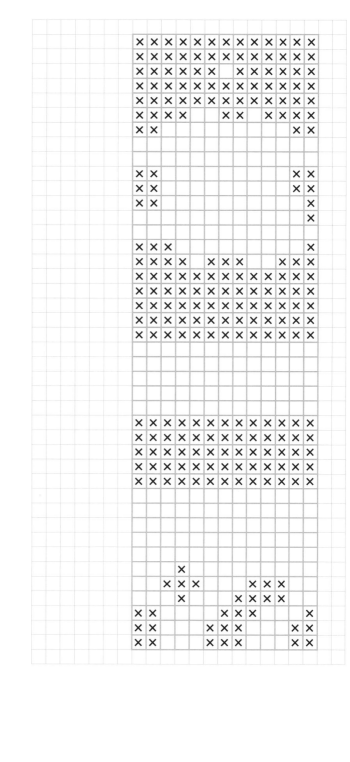

Fana

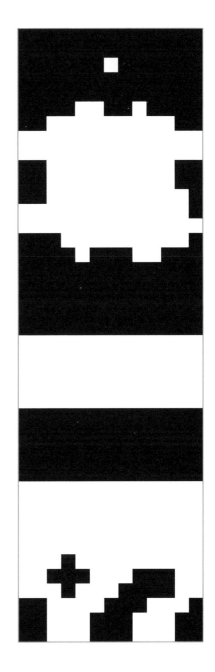

Selbu

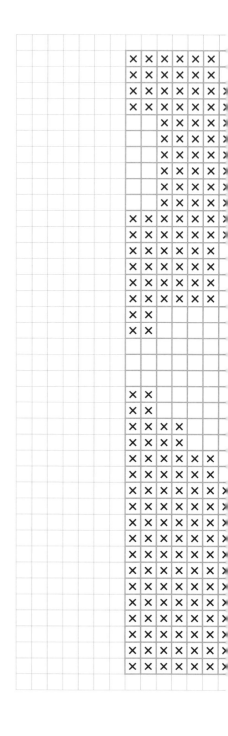

Selbu

ASKE-GÅRDEN
@ Mogens Canning Co A/S
Erfjordgata 8, Stavanger Øst
Mon, 1/3

SUMMARY KEYWORDS
norway
wearing
people
berlin
norwegian
regions
apartment
house
knitted
sweater
fireplace
heating
houston
sweaters
stay
wool
building
hard
nice
big
kids

CONSULATET
@ Viking Sardines
Dokkgata 7, Stavanger Øst
Tue, 1/4

SUMMARY KEYWORDS
norway
knitting
people
norwegian
fiddle
patterns
tonality
petroleum
knitted
sweater
folkmusic
switzerland
called
sweater
church
music
knitter
big
shipping
asia
tradition

°Cнαɟ

Stine Janvin What was your first encounter with a Norwegian knitted sweater?

Cory Arcangel I saw Espen Kluge, a friend, casually wearing a kofte. I thought it was a hipster thing, like wearing a trucker hat or something, but then I started seeing them more and more. I don't think in America we really have a parallel, something you see everyone wearing but don't really notice.

Stine Maybe a baseball cap.

Cory Yeah, that's a good point! That's exactly the equivalent.

Stine I have a long relationship to koftes, because my grandmother would make them for everyone in the family. I've been wearing them since I was a kid, and I still do. Everyone wears them—royals, kids, teenagers, hipsters, sports stars, criminals ... The biggest robbery in Norwegian history took place in the Nokas building here in Stavanger.

Cory Which building?

Stine The cash handler downtown, a vault basically. It was about twenty years ago, and the main guy, David Toska, showed up to his trial every day in a lusekofte. It was a strategic move, to disarm people, get sympathy, look more innocent. There was a lot of talk about it in the media.

Cory It's like in the States, how old-timey gangsters would come to court with a walker or cane. Like, "How could this kind old man be the head of the Gambino crime family?"

Stine Yeah, exactly, it has that same effect. Kofte sweaters are also believed to have protective powers or bring good luck. And it's functional for the weather. It keeps you warm, it's made of wool, so it stays warm even if it's wet.

Cory So what are these kofte things?

Stine When we talk about kofte today, it's usually either in relation to traditional Sámi clothing, or to a general knitted sweater or cardigan in thick wool with different patterns, often called a lusekofte.[1]

The history of the kofte and how it got interwoven with Norway is confusing, because there are a lot of different threads. One is that the word *kofte* likely derives from the Persian term *kaftan*, or a robe or tunic. The other is that the first knitted shirts in Norway were actually nightshirts that could be worn under your clothes like long-sleeved underwear. These were initially exclusive imports made of silk, with golden patterns on the sleeves and around the neck. They were coming from Southern Europe and were very similar to kaftans from the Middle East and Central Asia. The koftes we refer to today are similar to the sweaters worn as workwear by Norwegian fishermen in their function and wool quality, but have the details and decorative patterns of the nightshirts.

These different traditions and patterns merged into a Norwegian-nationalistic conception of knitting. In the 1800s, Norway broke away from Danish rule only to join the Swedish union, but it was trying to achieve independence.[2] So there was a real political motivation to find symbols to reinforce a Norwegian identity. Skiing, folk music, idyllic images of the fjords—all of that was popular. People were also encouraged by politicians to start knitting and to develop and carry on these knitting traditions.

In the late 1800s the yarn factories started branding certain patterns and naming them after geographical areas, which oftentimes didn't correspond with the factories' locations. This was the case with the Fana pattern, for instance.[3]

Cory So the pattern of the Fanakofte didn't come from Fana?

1 A lusekofte is a knitted wool jacket or sweater with a symmetrical pattern of single stitches (lus) in a color that contrasts with the base color of the sweater.
2 The Napoleonic Wars led to Norway's liberation from Danish rule, and in 1814 Norway got its own constitution and joined a union with Sweden.
3 Fana is a former municipality in the county of Hordaland, now a borough of the city of Bergen in Vestland County.

Stine Maybe parts of the design did, but the first Fanakofte design was apparently made in Sandnes. That's where the biggest knitwear factory in Norway is, still producing yarn and pattern designs.[4]

Cory How come traditional Norwegian music died out and koftes didn't?

Stine That's an interesting question. I mean, the tradition is actually not dead at all, it's still a big part of certain communities, and you can study folk music at several music academies. You could say that some parts and instruments of Norwegian folk music reached a higher level of mainstream popularity, though not in the same way as kofte.

Cory What parts are still popular?

Stine The Hardanger fiddle, for example, which by the way is quite Eastern-looking with the animal-head carving on the scroll and mother-of-pearl decorations. The Old Norse mythology aesthetic has a lot in common with Middle Eastern and Asian styles I find. Anyway, during the romantic nationalist era, the Hardanger fiddle became very popular, and was highlighted as something genuinely Norwegian.

Cory It also has resonant strings, which are not so often seen in the West. And I'm reminded of another traditional Norwegian instrument, the mouth harp, which is an instrument originally seen in China.

Stine They think that the first mouth harp came to Norway around 1200, though Norwegian folk music is traced back to the Old Norse era, which is basically the Viking Age. But in terms of modernizing, Norway is a very small, young country, so we were behind in every-thing. Even with knitting—all the other Nordic countries were doing knitting before Norway.

Cory And what was Norway doing?

Stine Farming, I guess. Picking potatoes and struggling. It was very poor. Going back to the popularization of Norwegian exports, you couldn't buy traditional Norwegian music in the same way as a kofte. It wasn't recorded, because the technology wasn't there until the early 1900s. And even then, it was just NRK [Norwegian Broadcasting Corporation] going around recording people playing in their houses.

Cory And the music never got industrialized.

Stine Do you know the composer Edvard Grieg?

Cory Oh yeah. He's one of the big guns. He got industrialized!

Stine Yes, he is considered one of the main Romantic-era composers worldwide. He was able to reach an international market by orchestra-ting folk tunes and making classical arrangements for symphony orchestra, piano, and smaller ensembles. Ole Bull, another musician from Bergen, also made the traditional music accessible for a bigger audience. He was a classical violinist and composer who started playing folk tunes at his concerts after he met and became friends with Myllarguten.[5]

Cory Traditional Norwegian music isn't really even Western, to my ears at least. When I first heard someone play the Hardanger fiddle in a traditional tuning, at a concert organized by Anders Hana as part of the Gorrlaus series here in Stavanger, the music sounded Indian or Middle Eastern to me. Not to mention the rhythm, which I could not for the life of me figure out—and I went to conservatory! It kept repeating in all these bizarre and hypnotic ways. The experience, overall, was totally disorienting.

Stine The tonality, I would say, is actually unique to Norway. The melodies are quite intricate and complex compared to, for instance, Swedish folk music, which is similar but usually has this very familiar, minor-sounding ring to it.

Cory Can you tell me a bit about the original tonality?

Stine Yes, so, when talking about Norwegian folk music today, we mostly think of up-tempo fiddle music, played in a virtuosic style with lots of ornamentation. The earliest styles are connected to the summer dairy farms, where they would use their voices and instruments for animal calls, scaring predators and communicating across valleys or between mountains. This is traced back to the Norse era, around 700–1050 AD, though the music we recognize as this style today is most likely from the fifteenth century. The instruments they would use were either the wooden *langelur* (which is a younger relative of the bronze lur), the *bukkehorn*, or the willow flute, which are all single hollow tubes that produce overtones when you blow air into the tube, and the tones vary depending on the strength of the airstream.[6] The mouth harp and *langeleik*, which is a sort of droned zither, are also connected to the earlier styles.[7]

4 Sandnes is a municipality and city in Rogaland County. Sandnes Garn has been a cornerstone business in Sandnes since 1888 and still operates today, with a turnover of 250 million NOK (about 29 million USD).
5 Myllarguten was a legendary Norwegian folk musician who played the Hardanger fiddle; he was a celebrity in the 1800s.
6 An overtone is any frequency higher than the fundamental frequency of a sound.
7 The langeleik usually has one melody string and up to eight drone strings. The earliest example found dates back to 1525, and it is the only instrument traditionally played by women in Norway.

The traditions from the dairy farms are unfortunately poorly documented and rarely practiced today, but composer and music theorist Eivind Groven in his 1927 book *Naturskalaen: Tonale lovar i norsk folkemusikk bundne til seljefløyta* [The Natural Scale: Tonal laws in Norwegian folk music bound to the willow flute][8] attributed the basis of Norwegian folk music and its tonal identity to the overtone instruments.[9]

The tonality became more advanced when new instruments like the fiddle and the Hardanger fiddle were introduced in the sixteenth century.

You'll find similar tuning systems in many Indigenous and folk-music traditions, not just in Norway, but the music here was mainly soloistic, meaning that the player was free to add unpredictable melodic and rhythmic twists and turns. One theory is that this is the reason why the microtonality was manifested in the music.

Cory When did these microtones get erased?

Stine It was a result of religion and modernization, and luckily they were not completely erased, but definitely reduced and underacknowledged. The Hardanger fiddle in particular was initially a party instrument. Weddings, wakes, and barn parties were typical occasions where people would dance to fiddle music as long as the fiddler kept going, which could sometimes be for three to four days straight. Some fiddlers would brag about learning their skills from Nøkken (the Nixie)[10] or the devil, and of course these parties also involved drinking, fighting, and other indecent behavior, so not surprisingly, it was in the church's interest to shut them down.

Cory The Nixie! I love it! [laughs]

Stine The Christianization of Norway had already begun in the Middle Ages, but there was still quite a pre-Christian culture, and perhaps because of the geography of Norway, with all its remote little villages and mountain farms, it wasn't until the 1850s that a wave of Christian revivalism led to a lot of players giving up their music. In some regions the fiddles were burned.

Cory Burning fiddles, yikes! They were not joking around.

8 https://archive.org/details/NaturskalaenTonaleLoverINorskFolkemusikk
 BundneTilSeljefloyta/page/n5/mode/2up
9 This assertion was not 100 percent correct, because the willow flute produces
 two overtone series, one with the tube open and one with a closed end.
 Players use their finger to open and close the opening.
10 In Scandinavian folklore, the nixie are male water spirits who play enchanted songs
 on the violin, luring women and children to drown in lakes or streams.

Stine I know! But during that same period, the romantic nationalists wanted to showcase the Hardanger fiddle onstage, so it was kind of a weird time. In many ways the institutionalization of the fiddle saved it from the revivalists, but it also completely changed its function and moved it from the barn to the concert house. It got tamed. At the same time, international influence and imported instruments like the piano, harmonica, and especially the accordion, pushed the traditional players' tuning and musical style in new directions. It became more popular to play in groups, and the old playing styles were considered out-of-date by younger generations.

Good thing modernization happened so slowly here, because there were still some old players left when they started recording out in the villages in the early 1900s.

Cory Is it because Stavanger is a city that this music vanished here so much quicker than it has in the villages?

Stine Apparently it's a misconception that outside influence washed it out, but I can't help thinking it must have something to do with it. There are also no known traditional musicians from Bergen, for instance, but there is a strong tradition in the villages around the city. But generally the church music had a lot to do with it—at some point religious psalms were the only music that was okay to play, so the fiddlers would play that instead of dance music. There is a village not too far from here, Bjerkreim, where the tradition was kept longer, or somehow they managed to find their way back to it.

Cory Do you know why the church didn't manage to erase the traditional tunings there?

Stine Well, actually the tradition was shelved and forgotten for a long time, but one of the local fiddlers, Ivar Fuglestad, later became an important source from that area. Because his wife was so religious, he had not played any dance tunes in, like, forty years, but after she died, he started playing again and a lot of it was recorded, so that is how it lives on.

Cory How far are we in Stavanger from going and hearing some music at a family party in the fjords, where someone is playing the Hardanger fiddle in a traditional tuning? Is it more like five minutes or three hours?

Stine If Morten [Joh] and Anders [Hana] don't count, more like three hours, unless you're lucky.[11] You have to know where to go; you can't just show up anywhere and expect people to be playing the fiddle.

11 Morten Joh and Anders Hana's traditional Norwegian microtonal electronic dance music duo Naaljos Ljom https://naaljosljom.bandcamp.com/

Cory You mentioned earlier that the crazy thing about Norway's geography is that all these little towns are so remote. Every single little town is literally in the middle of nowhere. It's so shocking to me that these places exist, but I guess the water is what connects them all.

Stine Yeah, water, and the travel routes like the Setesdal, which is a valley where the distinct tonality is kept and is still practiced. It's normal to think, "Oh, but that's because the area is so remote." But actually it's not, because people would travel through the Setesdal when they were coming from the south coast and traveling over the mountains to Bergen. So it was part of this route.

Cory So there was some sort of inverse relationship, because a town had to have some access to the world, since these tunings and instruments come from elsewhere. But for that traditional music to not have died out, the place needed to not be Bergen. It's right in the middle.

I don't think Norwegians know this, but among immigrants, Norway has the reputation of being one of the hardest places to immigrate to in Europe. While European on paper, its day-to-day culture, maybe due to its remoteness, is only tangentially European. And for me, practically, this is often expressed interpersonally. Here you could be sitting next to a Norwegian Nobel laureate at dinner and you wouldn't find out during the dinner. After the dinner you'd ask someone, "Who was that?" and they'd say, "Oh, that person is a famous scientist who discovered a neutron," and you'd be like, "Oh, okay. Well, that would have been great to know when I was sitting next to them!" That's very Norwegian—everybody keeps their cards to themselves. I had heard that it has to do with survival culture, combined with Protestantism. You only talk when it's like, "Can I borrow some potatoes? I'm starving to death."

Stine Ha ha, yeah, except you would never even say that! My grandmother was living alone up on a hill, in the middle of winter, completely snowed in, but she would never ask her neighbor for help. I think it was a "never ask for what ought to be offered" kinda thing. Luckily I don't relate to this; I don't mind asking my neighbors for help or potatoes—it's nice to connect.

Cory Small talk was a sin in hard-core Protestantism. And Protestantism is the air that people here still breathe; it is behind every interaction.

Stine Even in the kofte, a lot of the patterns also have to do with Christian symbols, and wearing them would allegedly protect you from evil. And chatting …

Cory And chatting! LØL. Yeah, exactly, or telling somebody that you did something special.

I had a student in my art class who was a knitter, and she was the only student who wasn't staring at her phone all the time. I think that the phone is the new knitting or something. A real knitter, they're knitting everywhere, they just whip out that bag. I feel like there's some relationship between the progress of knitting and whatever the opposite progress is when we go on our phones. I would like to become a knitter to get rid of the phone.

Stine It can be really meditative. I started a couple of projects, ambitiously trying to make a sweater—for Isof, for instance. I think I finished one tiny hat when he was a newborn.

Cory I tried it before Embla was born. I was learning knitting and Ableton Live. You have so much more time before kids are born, but then it was all out the window.

Stine Right. But to be honest, knitting also gave me neck pain. My shoulders and hands got super tense from holding those knitting needles.

Cory Oh, okay, then it's not for us.

Đɛɛρ/Tυnɛd' ΓαTtεΓυ§

Setesdal

Fana

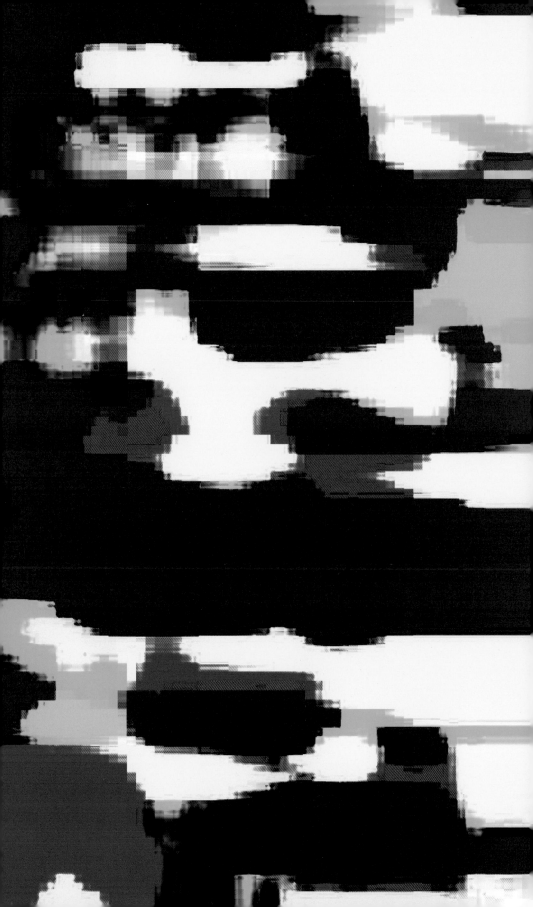

Selbu

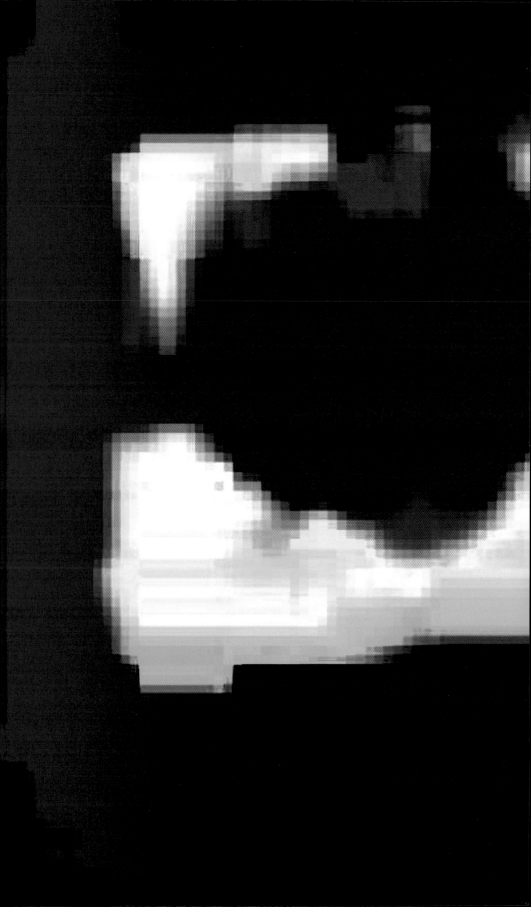

Identity Pitches
© 2022 Stine Janvin and Cory Arcangel

ISBN: 978-1-7377979-1-3

The rights to the work remain the sole property of the author.
All rights reserved. No part of this publication may be reproduced,
stored in retrieval systems, or transmitted in any form or by any
means, electronic, mechanical, photocopying, recording, or
otherwise, without prior permission from the copyright holder.

Managing Editor: Hiji Nam
Graphic Designer: Benjamin Hickethier
Copy Editors: Allison Dubinsky and Meg Miller

Primary Information
The Old American Can Factory
232 3rd Street, #A113
Brooklyn, NY 11215
www.primaryinformation.org

Printed in The Netherlands by Drukkerij Tielen B.V.

This book was conceptualized, realized, and designed
in Stavanger Øst, Norway, at Consulatet. Additional support
was provided by Arcangel Software.

This publication features the following typefaces: Standard Book
by Bryce Wilner; DSE Typewriter by Darren Embry; Satyr by Sindre
Bremnes; Arial Unicode MS by Brian Allen, Evert Bloemsma, Jelle
Bosma, Joshua Hadley, Wallace Ho, Kamal Mansour, Steve Matteson,
and Thomas Rickner; as well as the Human Readable Type keyboard
plug-in by Julieta Aranda, Fia Backström, and R. Lyon.

Cory Arcangel would like to thank Am Schmidt, Henry Van Dusen,
Josie Keefe, Rute Ventura, Hanne Mugaas, and Embla Arcangel.
Stine Janvin would like to thank Mia Koch, Morten and Isof Joh
and Annemor Sundbø for her books *Koftearven* and *Kverdagsstrikk:
Kulturskattar frå Fillehaugen*.

Primary Information is a 501 (c) (3) non-profit organization that
receives generous support through grants from the Michael Asher
Foundation, Empty Gallery, the Graham Foundation for Advanced
Studies in the Fine Arts, the Greenwich Collection Ltd, the John W.
and Clara C. Higgins Foundation, Metabolic Studio, the National
Endowment for the Arts, the New York City Department of Cultural
Affairs in partnership with the City Council, the New York State
Council on the Arts with the support of Governor Andrew Cuomo
and the New York State Legislature, the Orbit Fund, the Stichting
Egress Foundation, VIA Art Fund, The Jacques Louis Vidal
Charitable Fund, The Andy Warhol Foundation for the Visual
Arts, the Wilhelm Family Foundation, and individuals worldwide.
In addition, Primary Information receives support from the Henry
Luce Foundation, the Willem de Kooning Foundation, and Teiger
Foundation through the Coalition of Small Arts New York.